How to Draw
Monsters

In Simple Steps

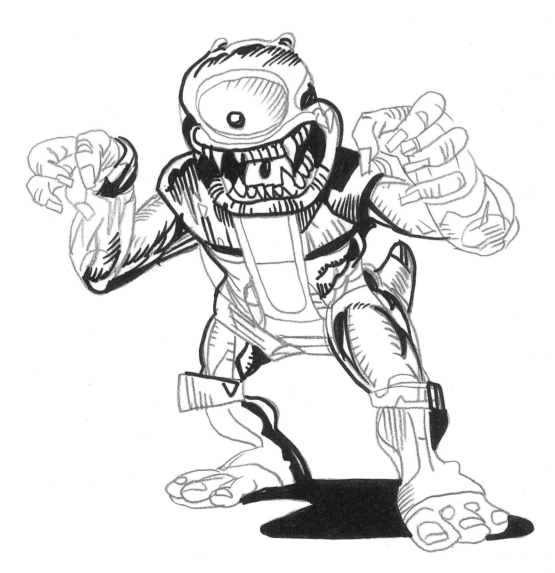

First published in Great Britain 2012

Search Press Limited
Wellwood, North Farm Road,
Tunbridge Wells, Kent TN2 3DR

ISBN: 978 1 84448 795 0

Printed in Malaysia

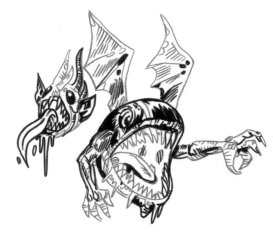

Dedication

Dedicated to good friends who mean a lot; Jah Wobble, Karl Hopper-Young, Becky Beasley, Louise C, Danny M, Jay B and all the others…

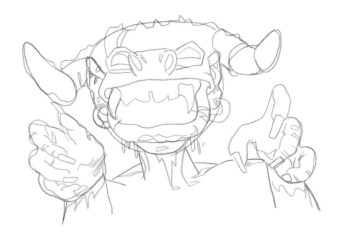

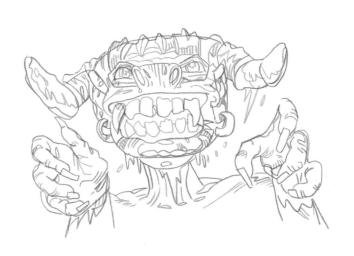

Illustrations

How to Draw
Monsters

In Simple Steps

Jim McCarthy

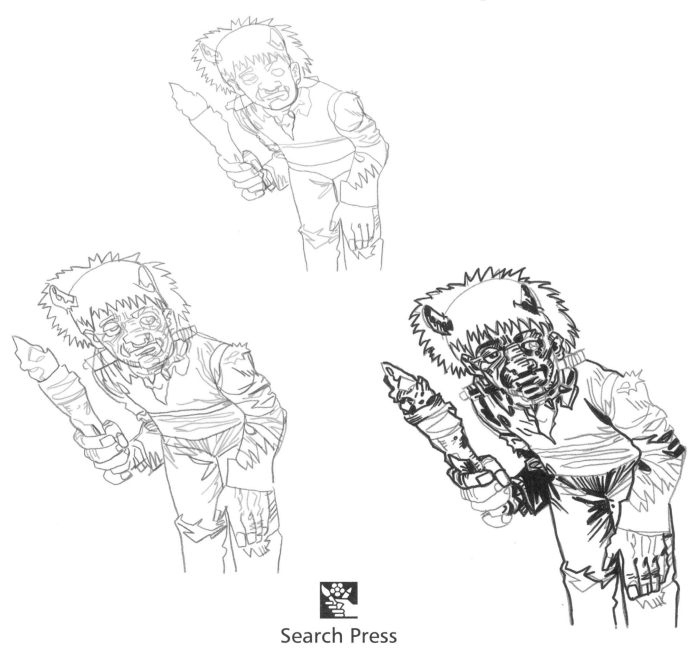

Search Press

Introduction

Welcome to *How to Draw Monsters*. This book shows you how to create twenty-eight scary, funky, and downright cool monster drawings using easy to understand techniques.

I love monsters. When I was younger, I spent lots of time dreaming up new ways to draw monsters and the possibilities seemed endless. There are just so many ways to draw monster characters – they can be cute, angry, ghostly or even grotesquely monstrous!

Each drawing takes you through a sequence of basic steps, which are followed by a tonal ink drawing and the finished colour artwork. To make the drawing process easier, first I sketch out the basic, simple shapes for the face and/or body; these are usually circles, ovals or sausage shapes. I draw these initial shapes using a soft blue pencil, and another colour, red, is introduced in the second and subsequent stages to illustrate what has gone before. When copying steps, it is better for you to start off by using a soft pencil, such as an HB or something even softer like a B or 2B, but feel free to use whatever tools you are most comfortable with. Using this drawing technique means that the process is simplified and you can easily follow the stages to the finished drawings.

After drawing the monsters at each stage, I scanned my finished ink drawings into my computer and coloured the drawings digitally. You can also use paints such as watercolour or gouache, or permanent markers to colour your artwork.

This is all about being creative and having fun, and practice will bring out the best in your drawings. I have included a variety of different monsters, which I hope you will love. I hope they will inspire you to invent your own. Remember it's all about adding monstrous features so don't forget the fangs, big teeth, hairy tufts, strange eyeballs, menacing faces and grotesque expressions!

Have lots of fun drawing monsters.

Happy Drawing!

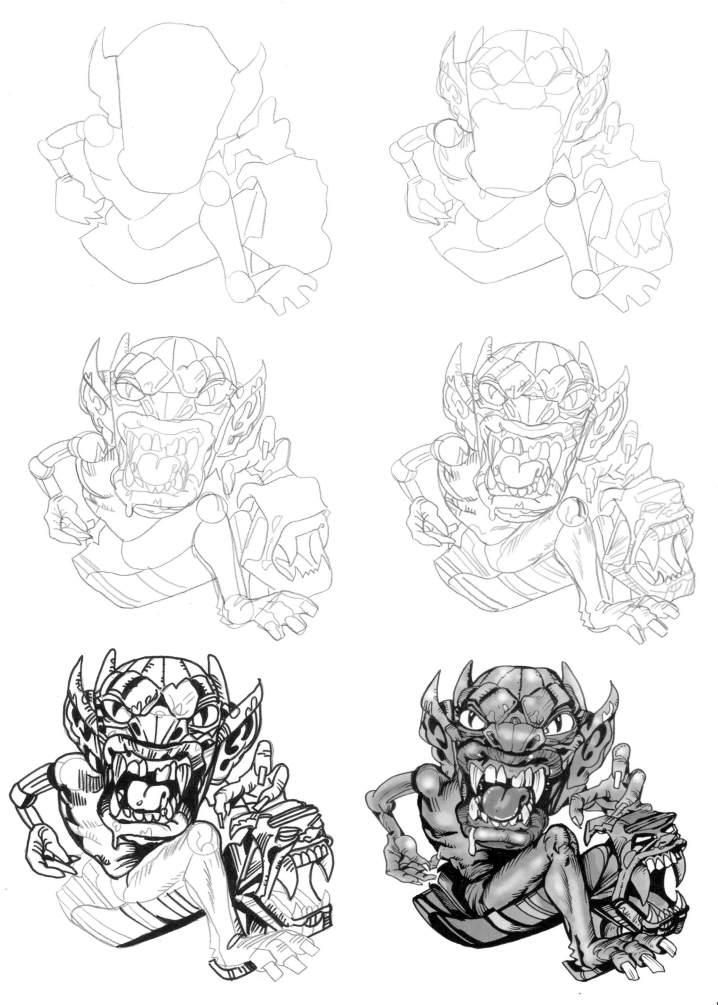

5

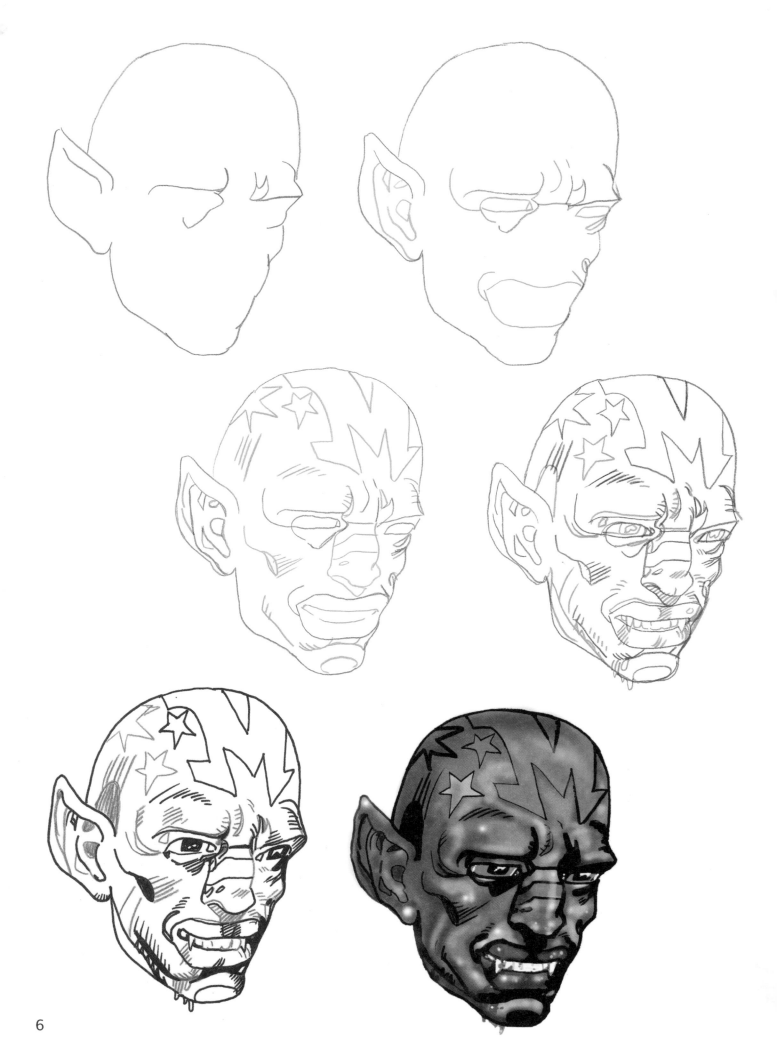

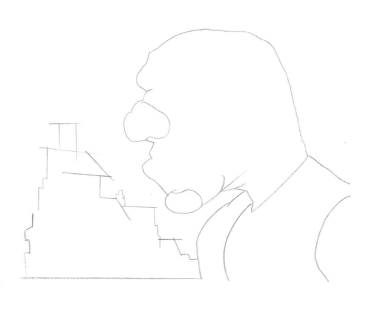

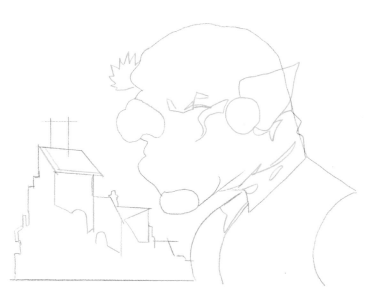

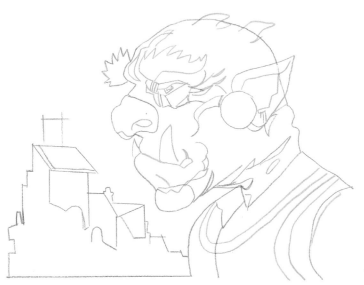

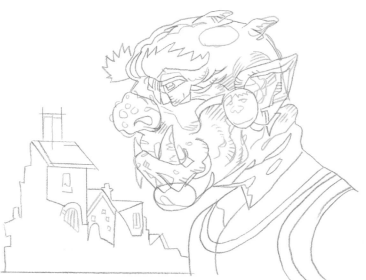

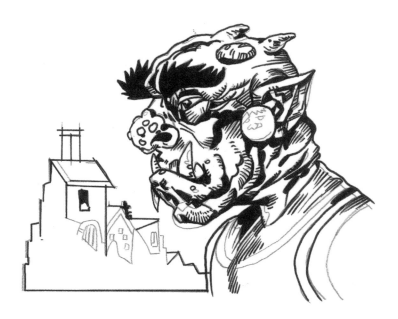

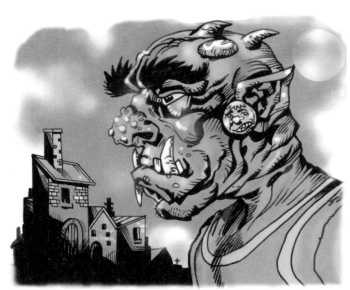

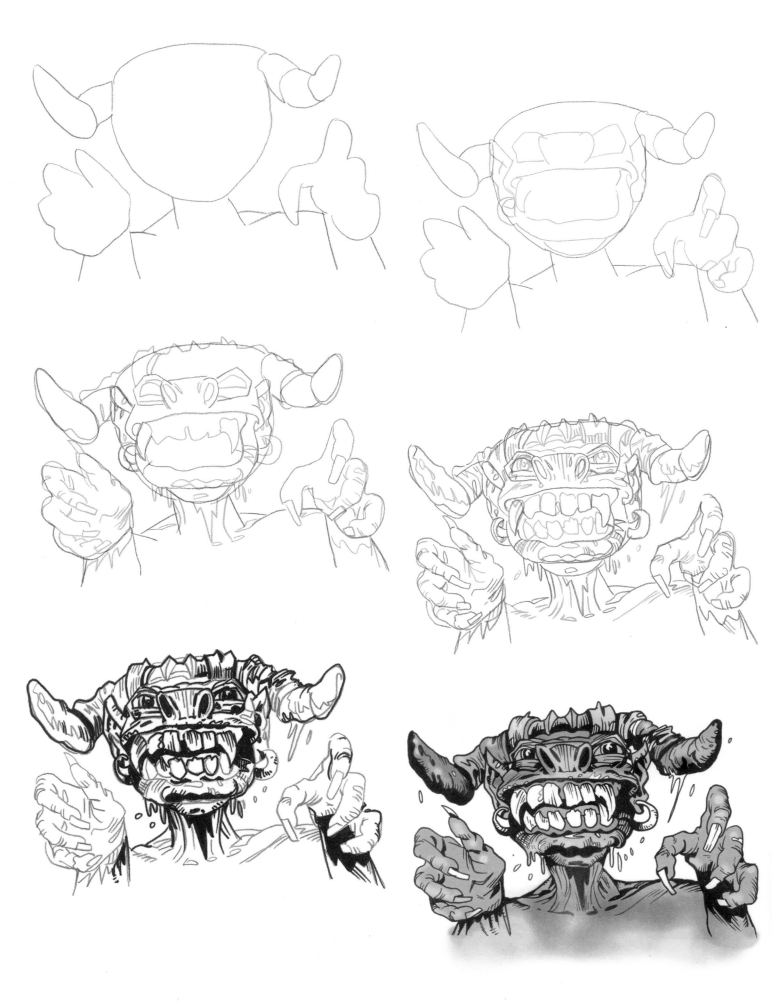

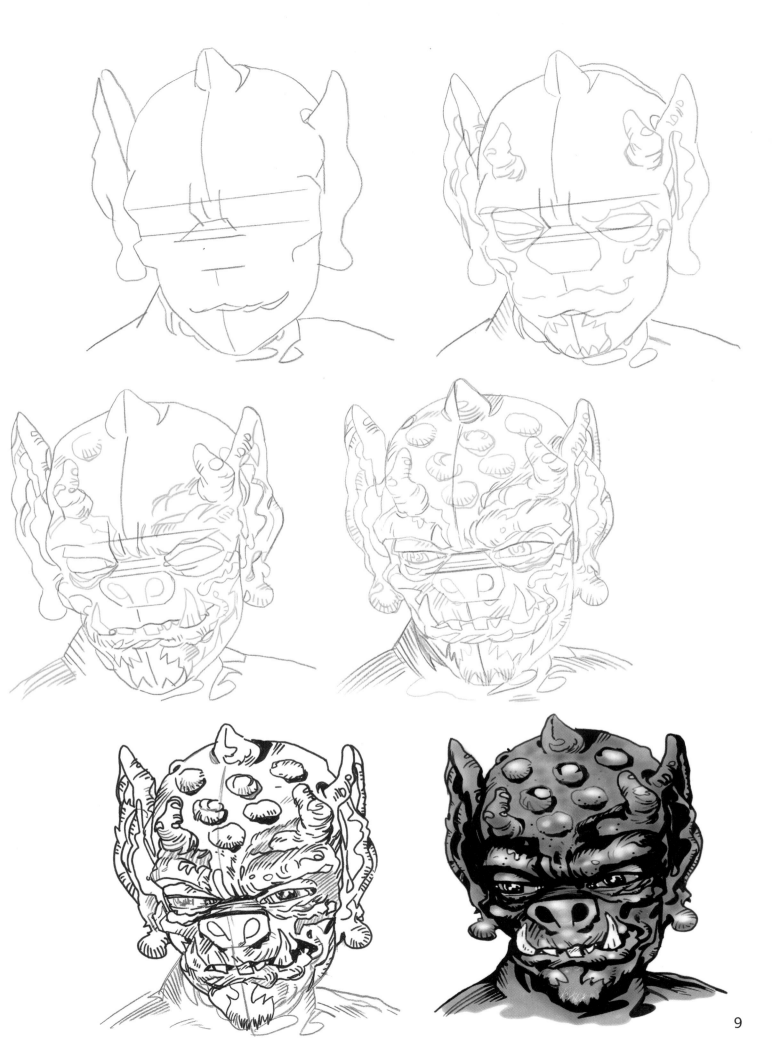

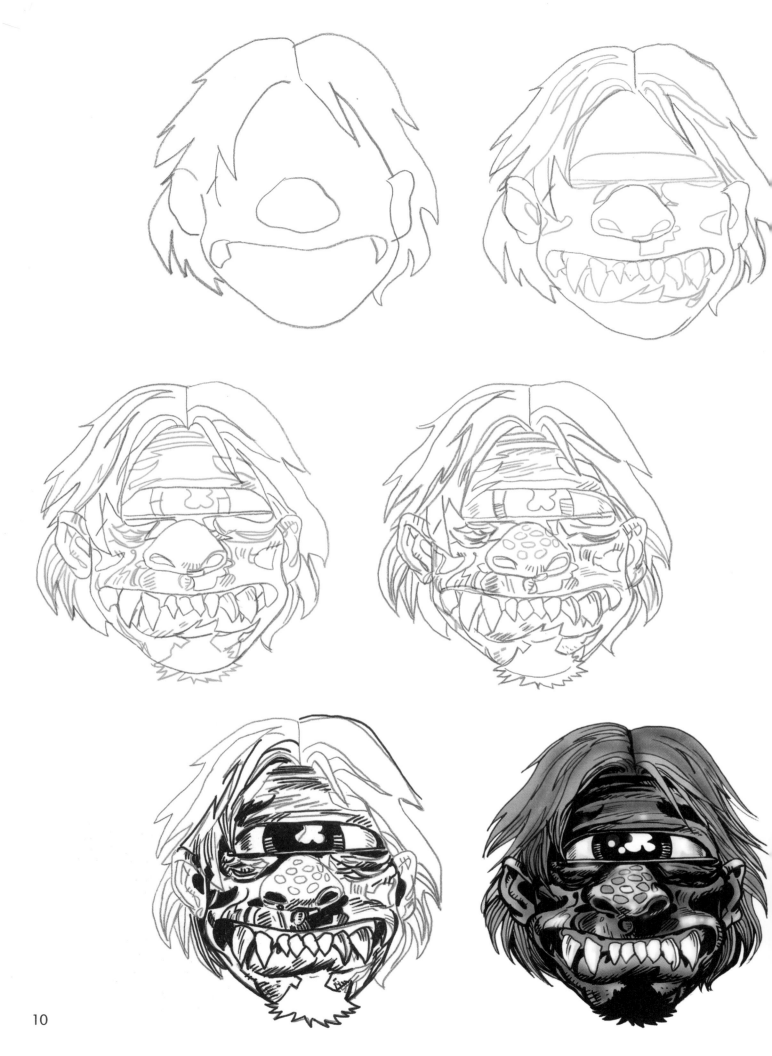

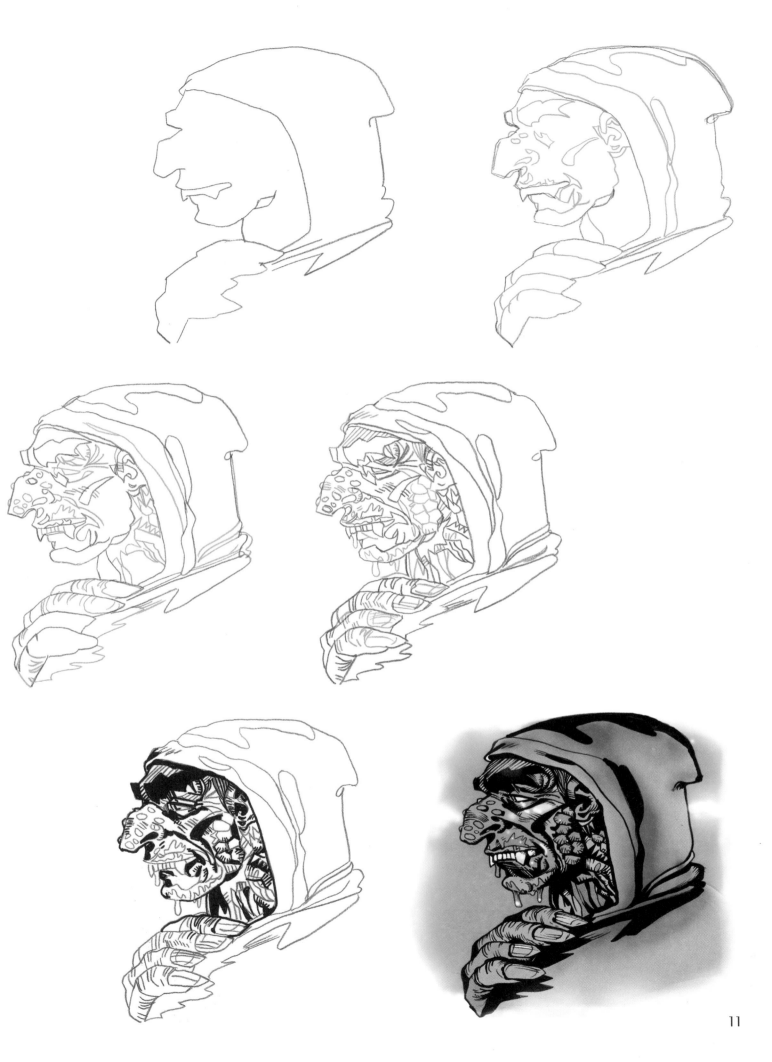

11

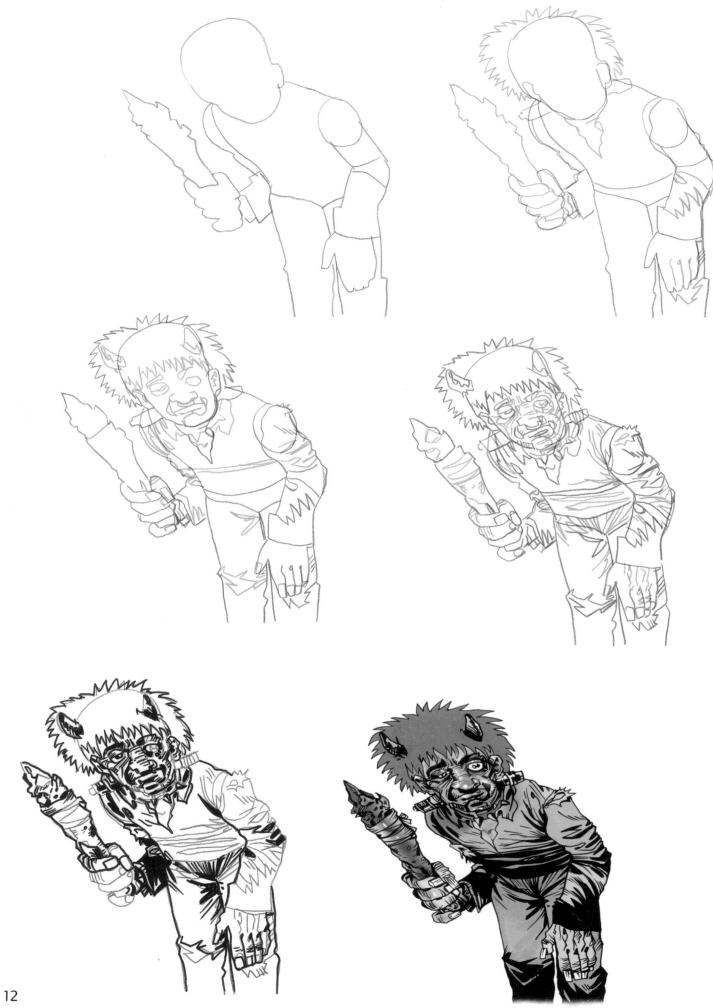

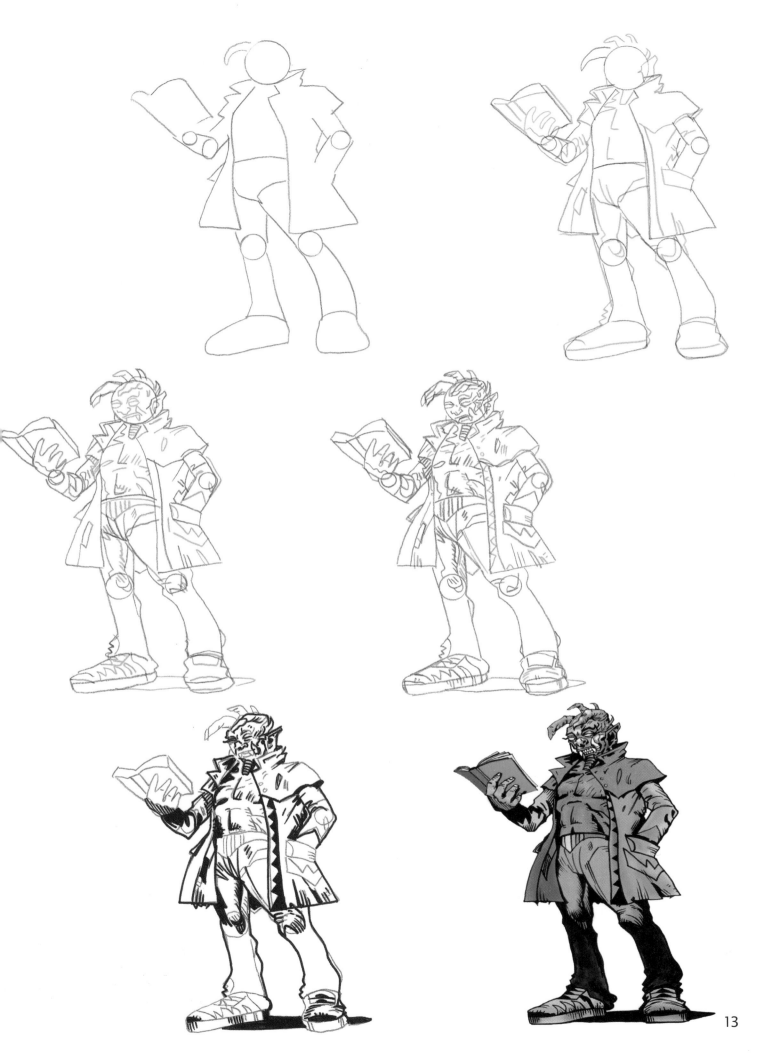

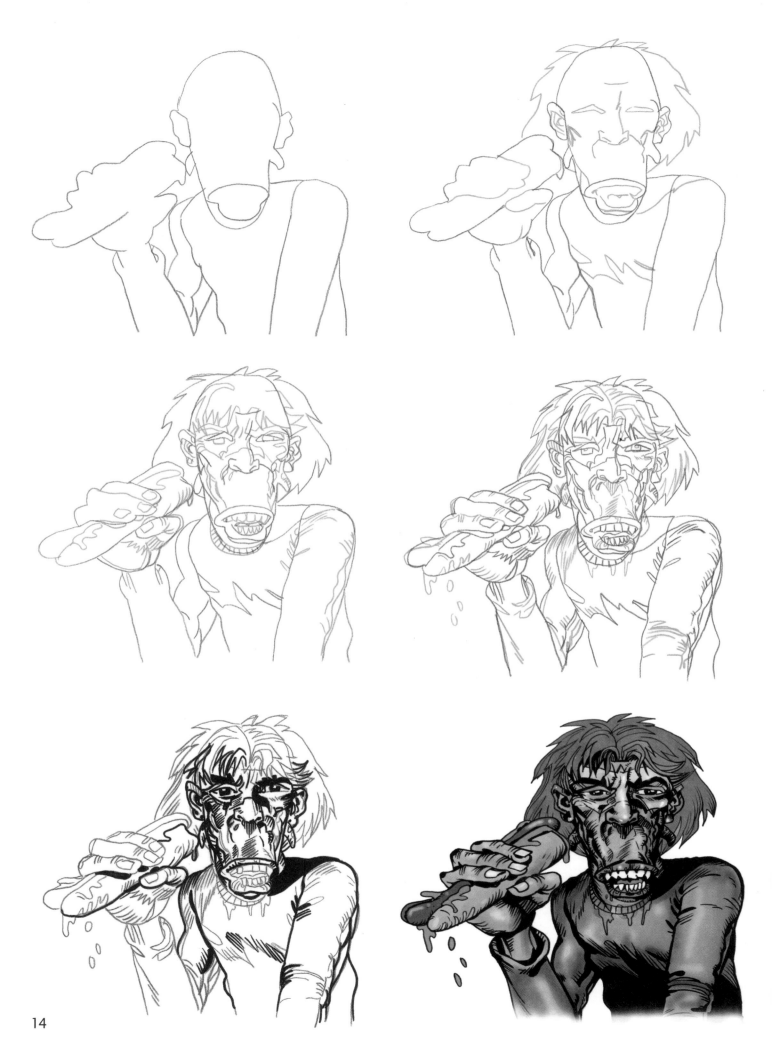

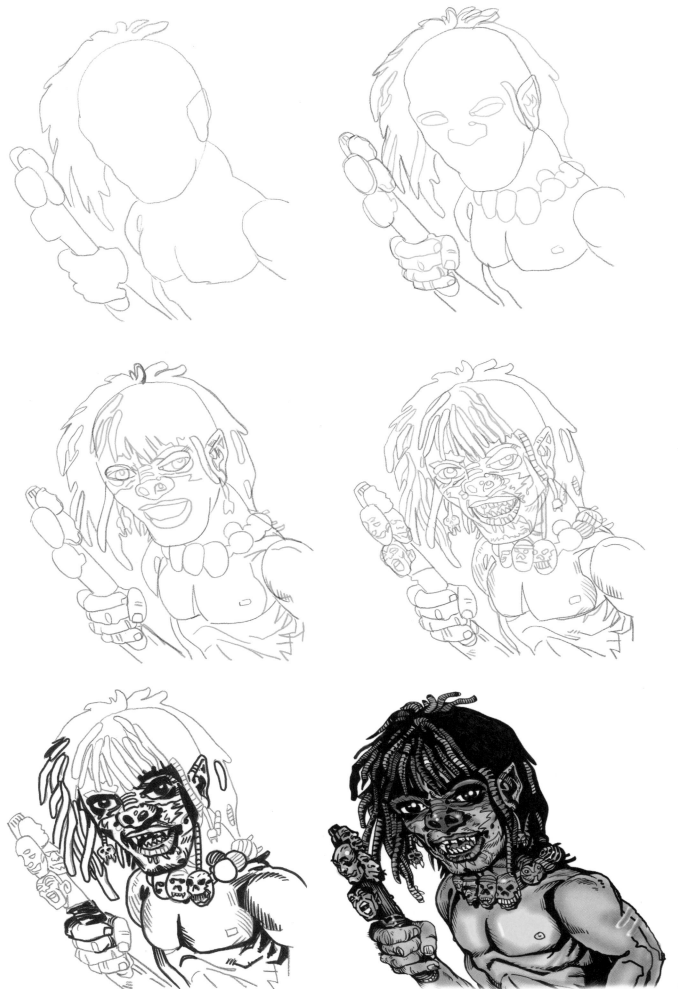

15

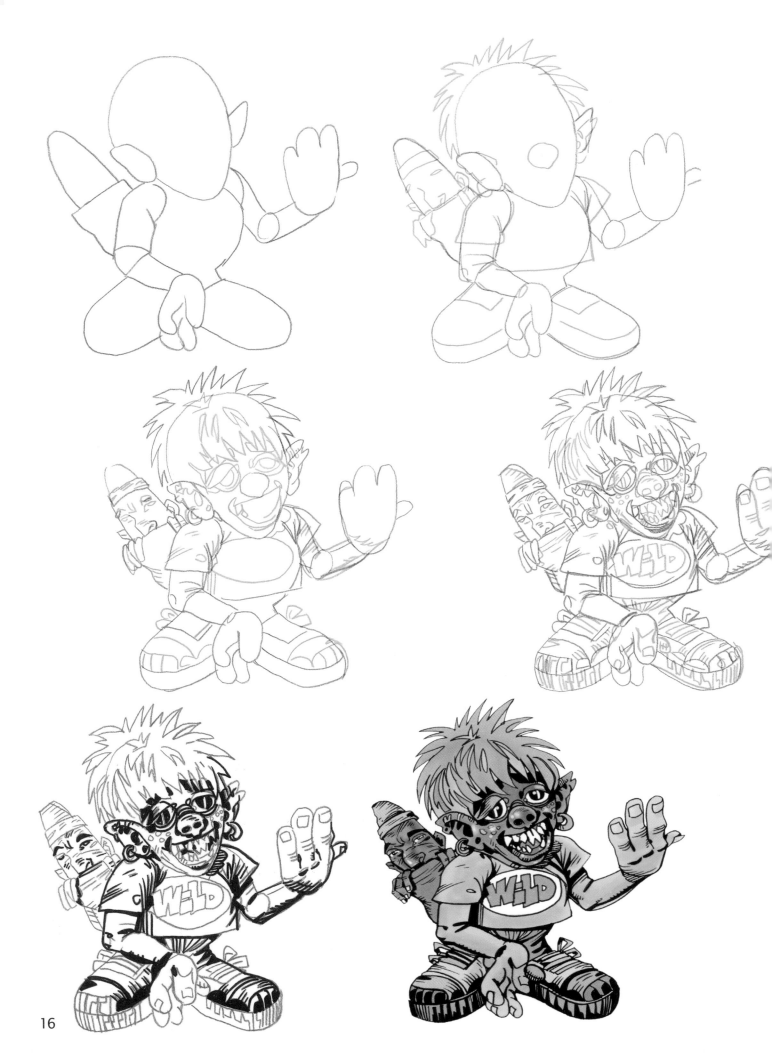

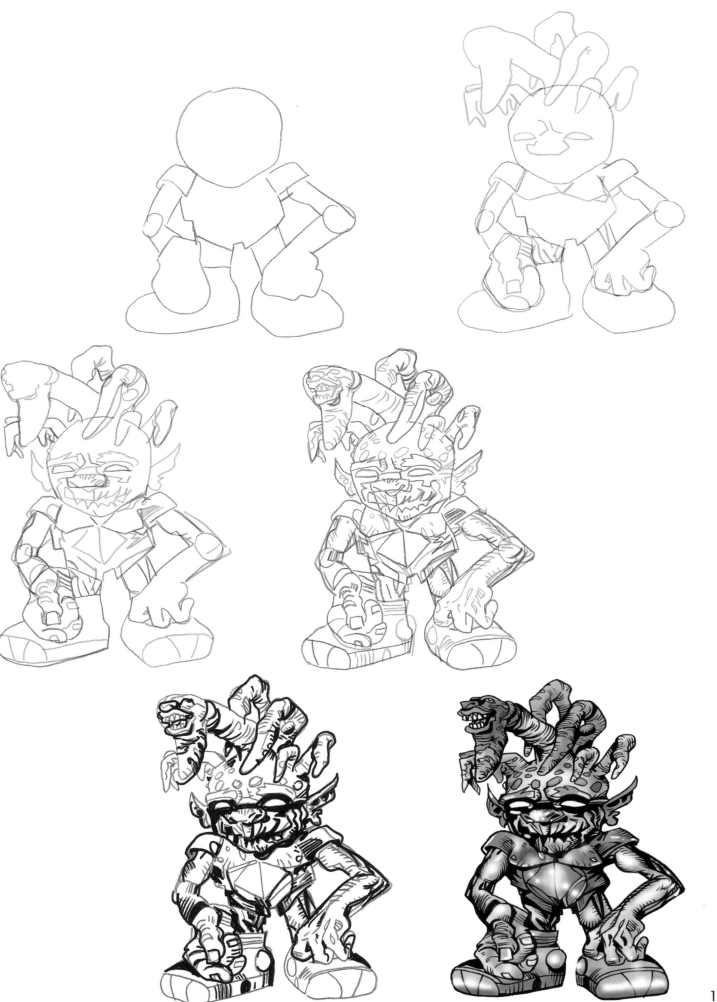

17

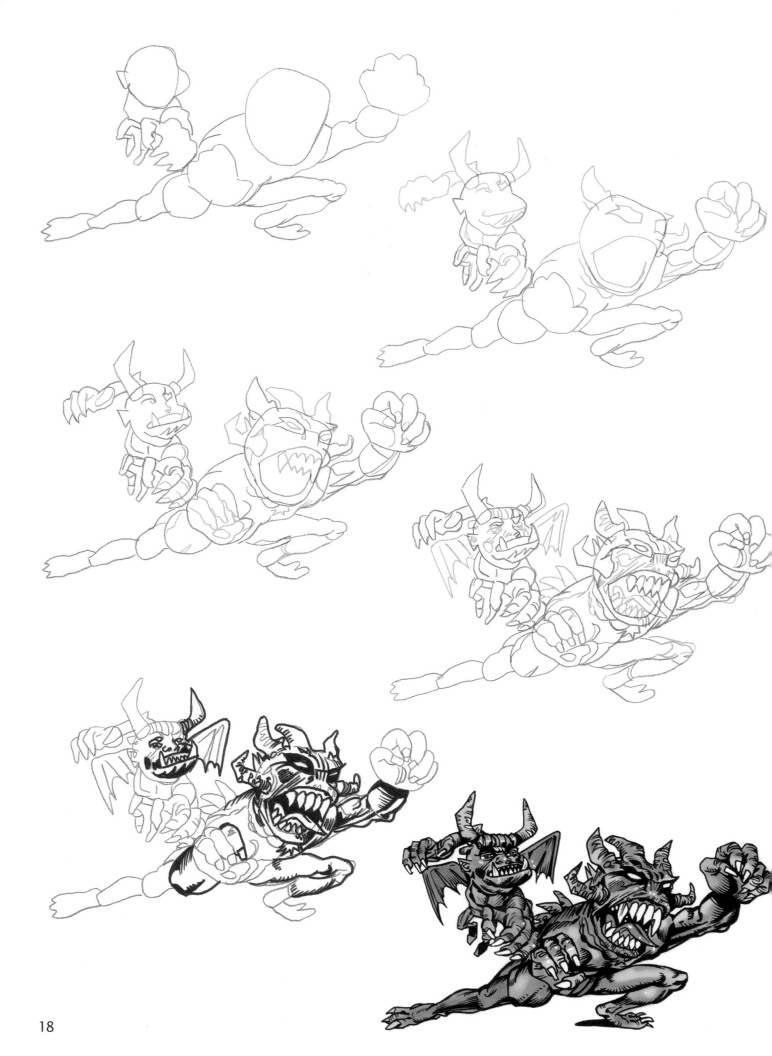

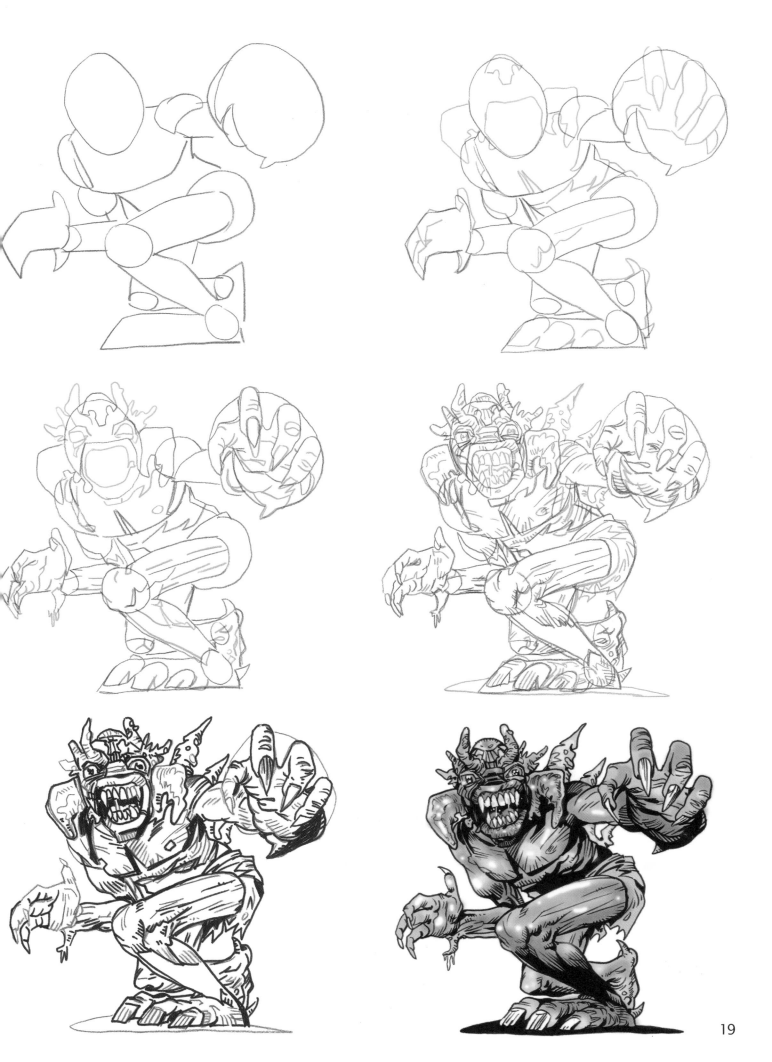

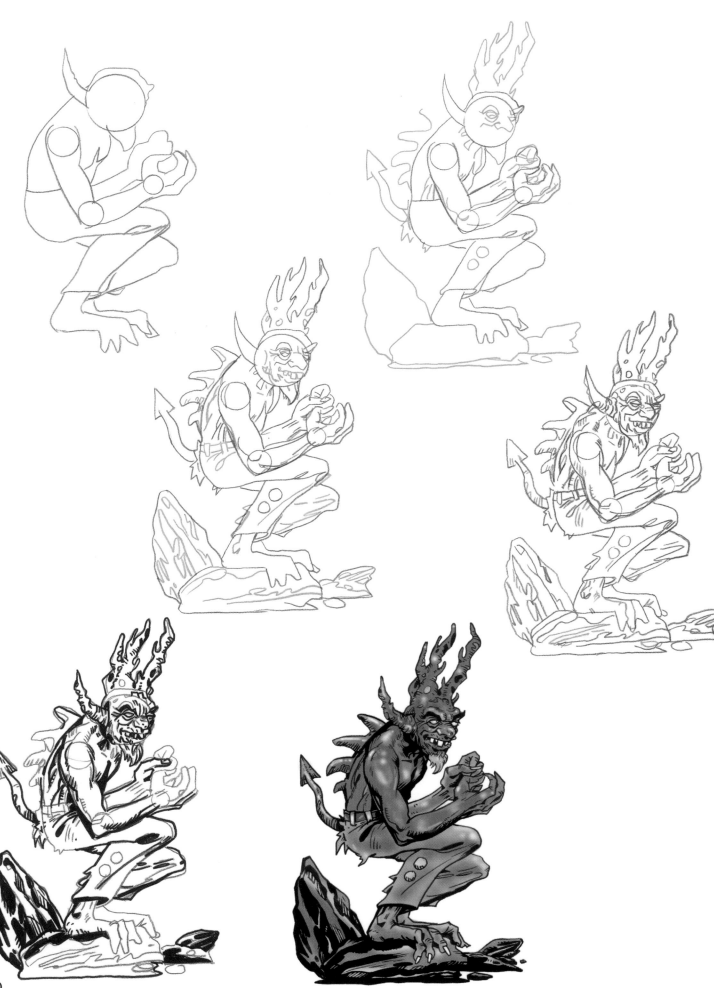

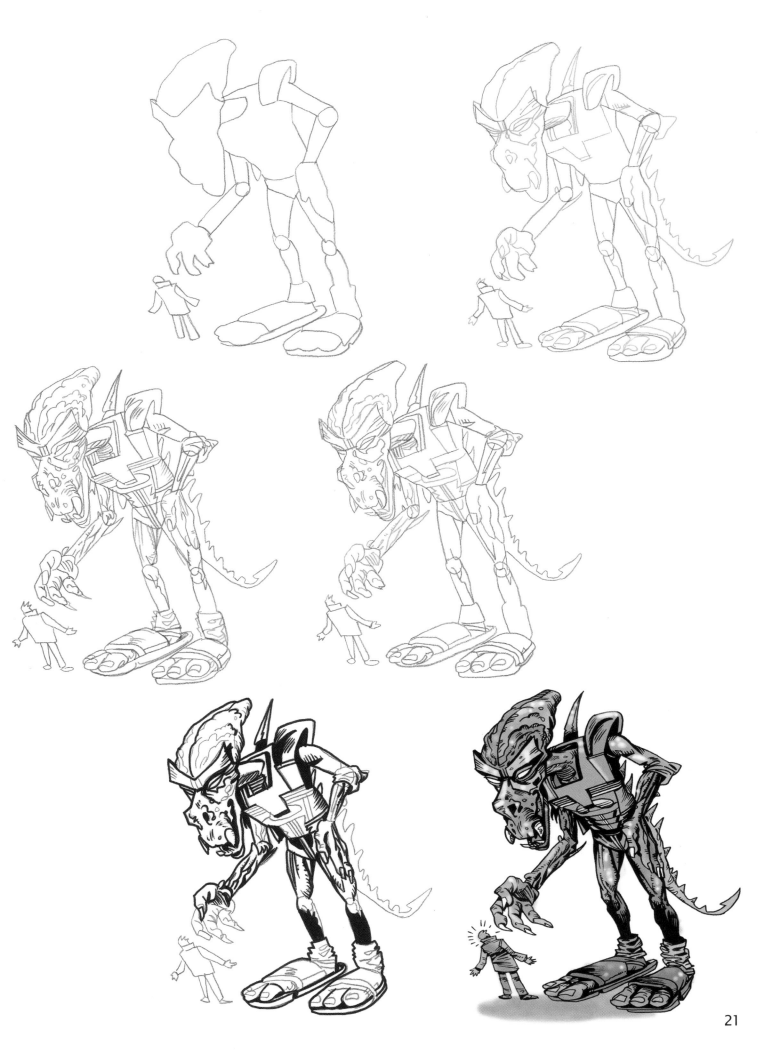

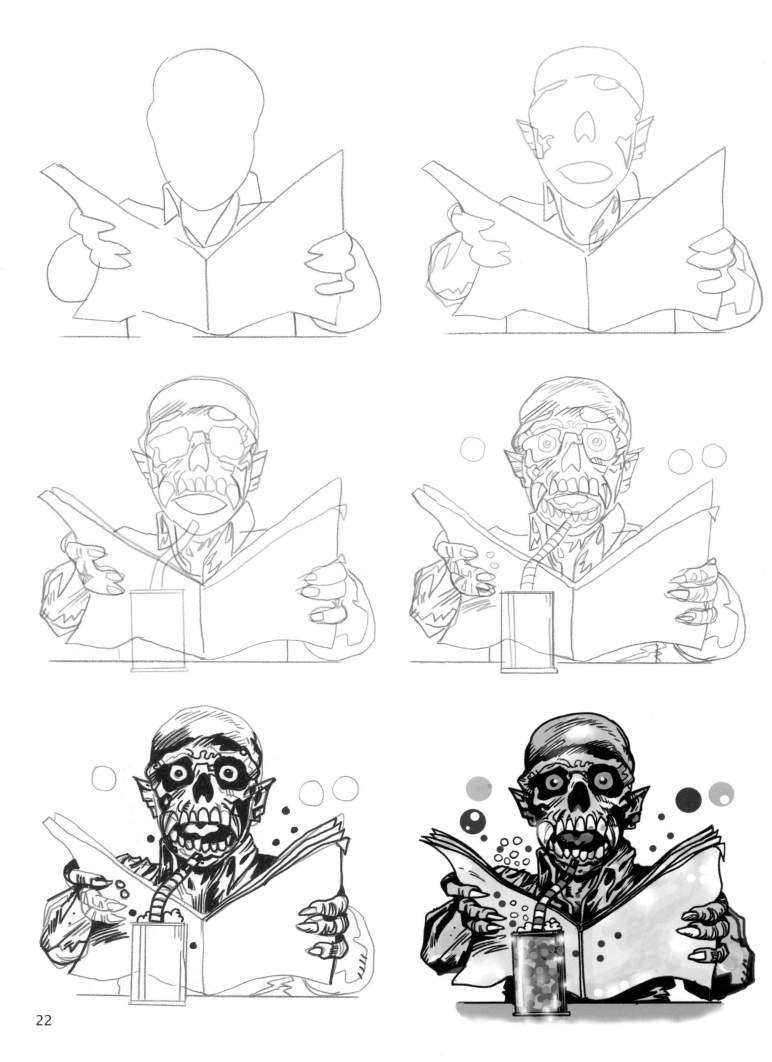

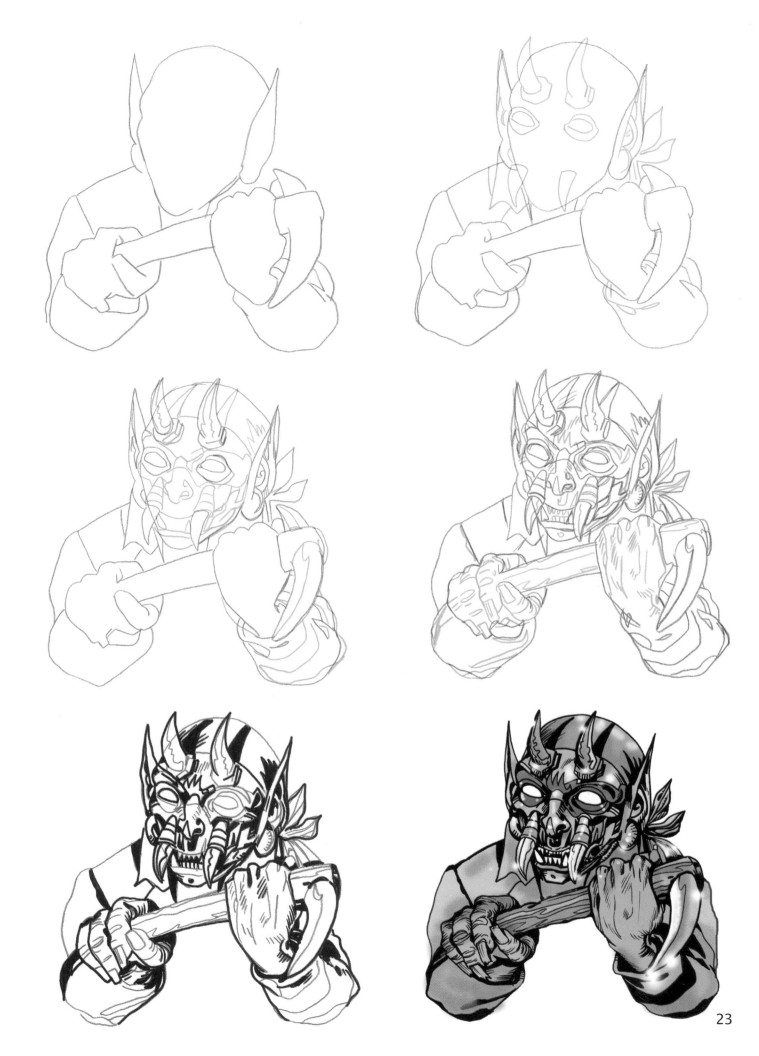

23

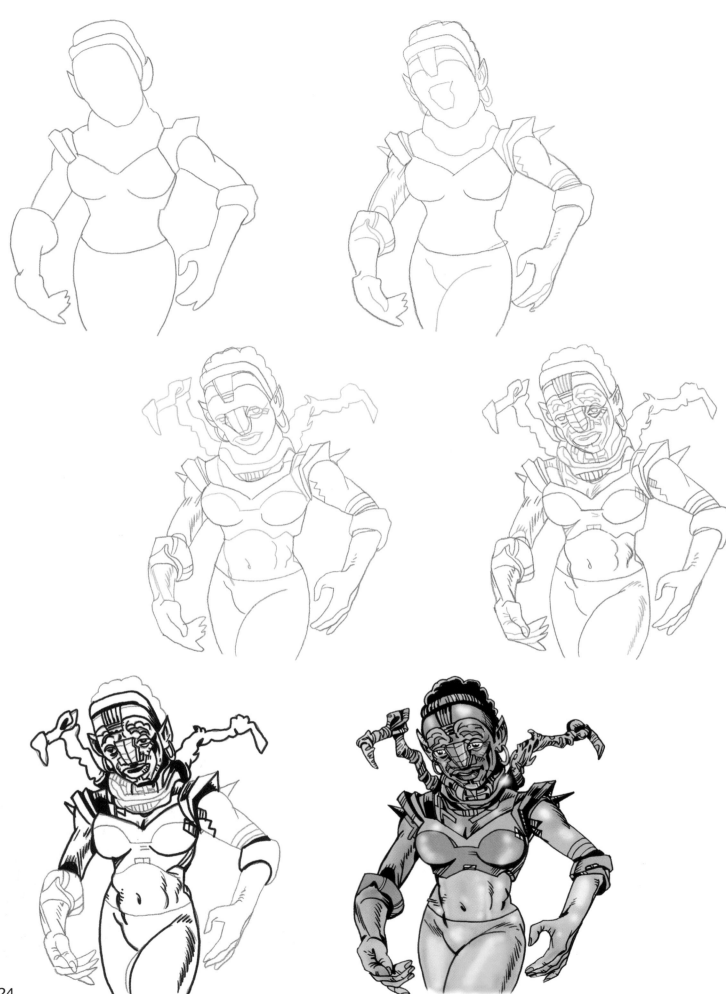

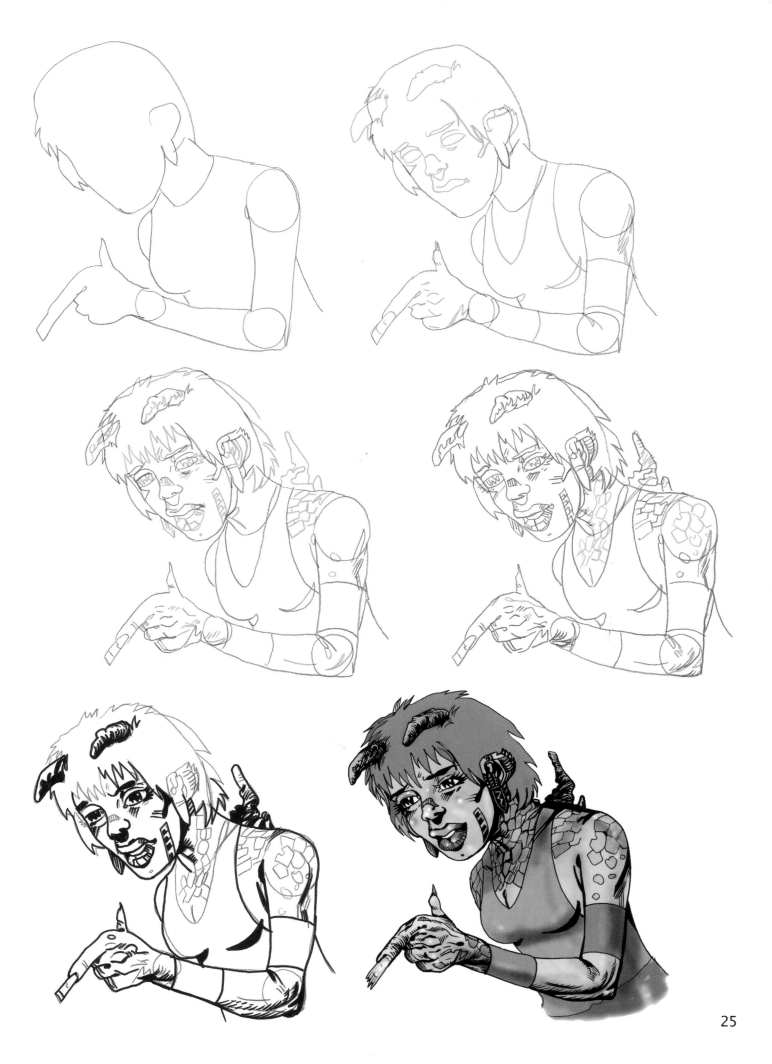

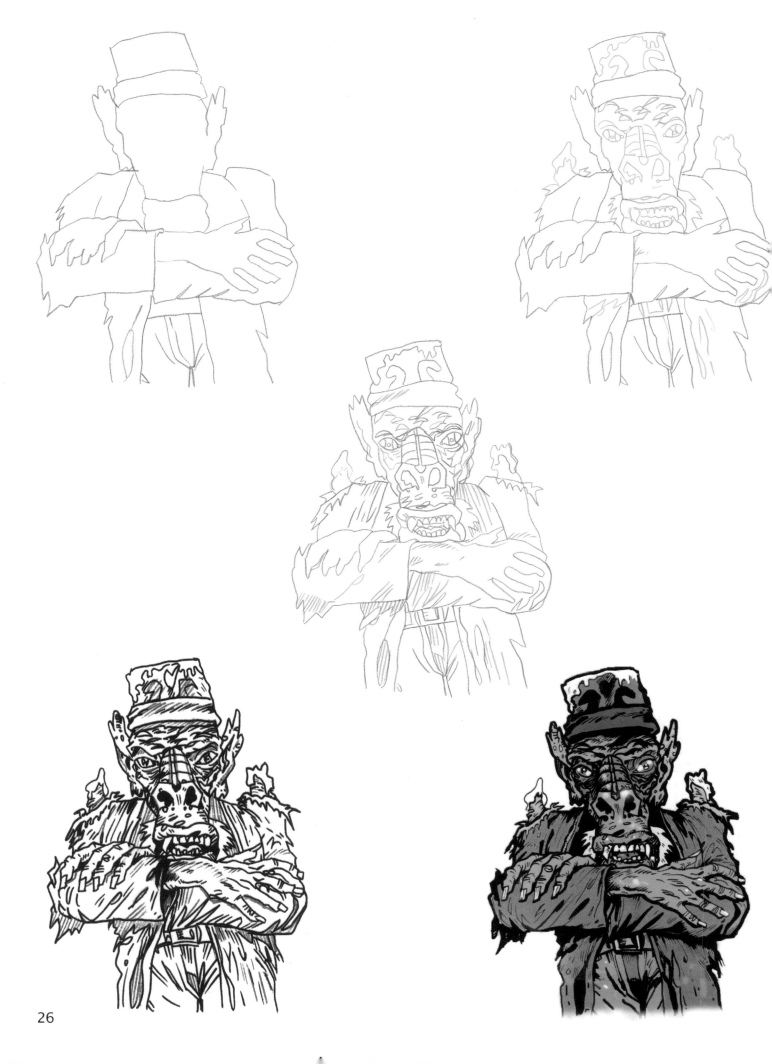

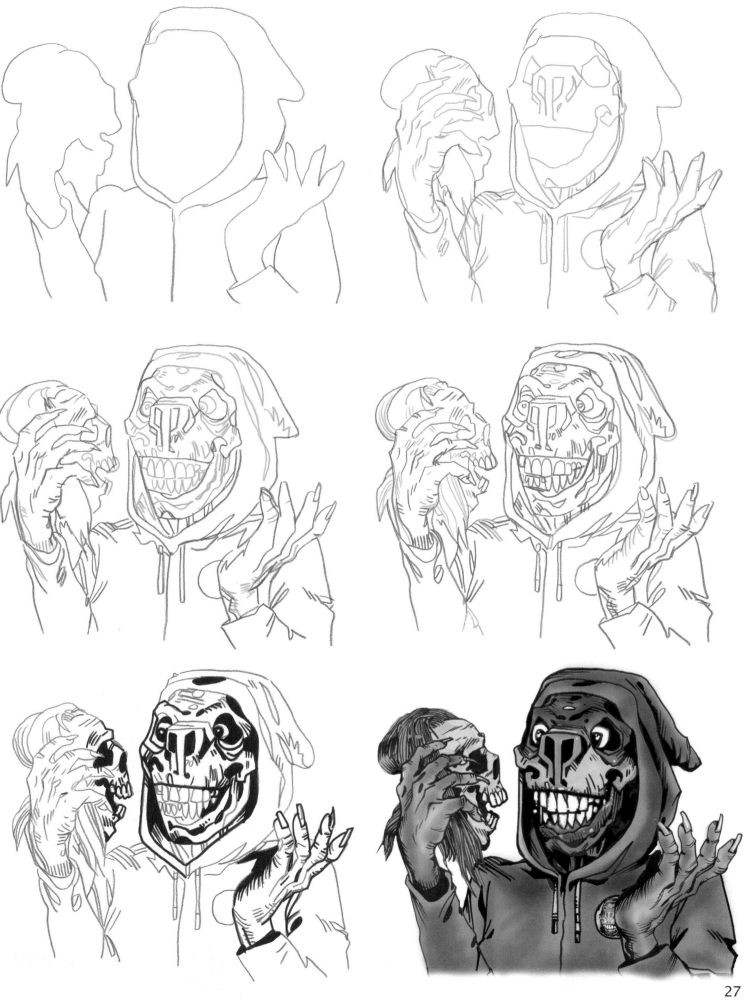

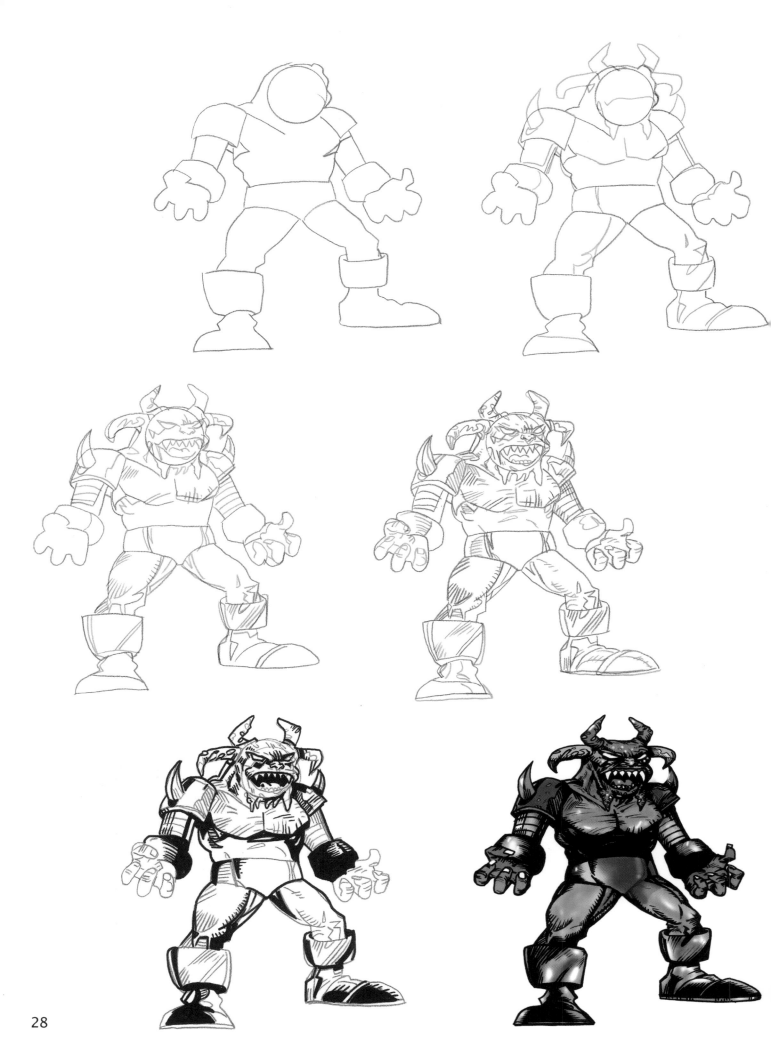

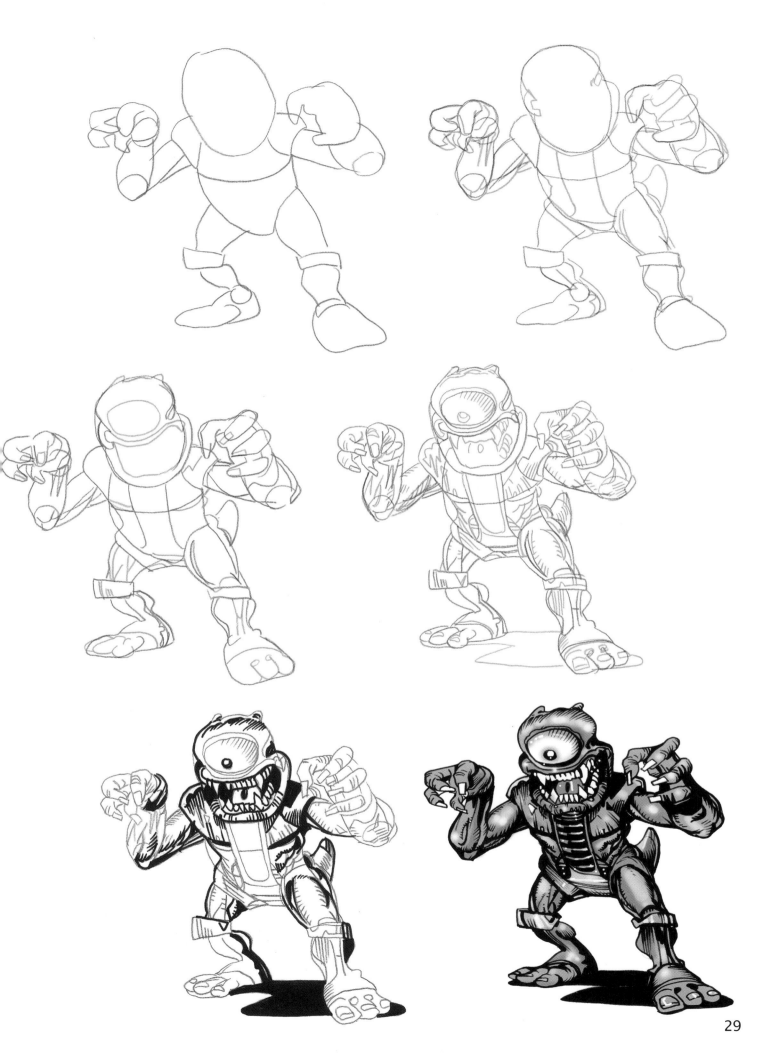

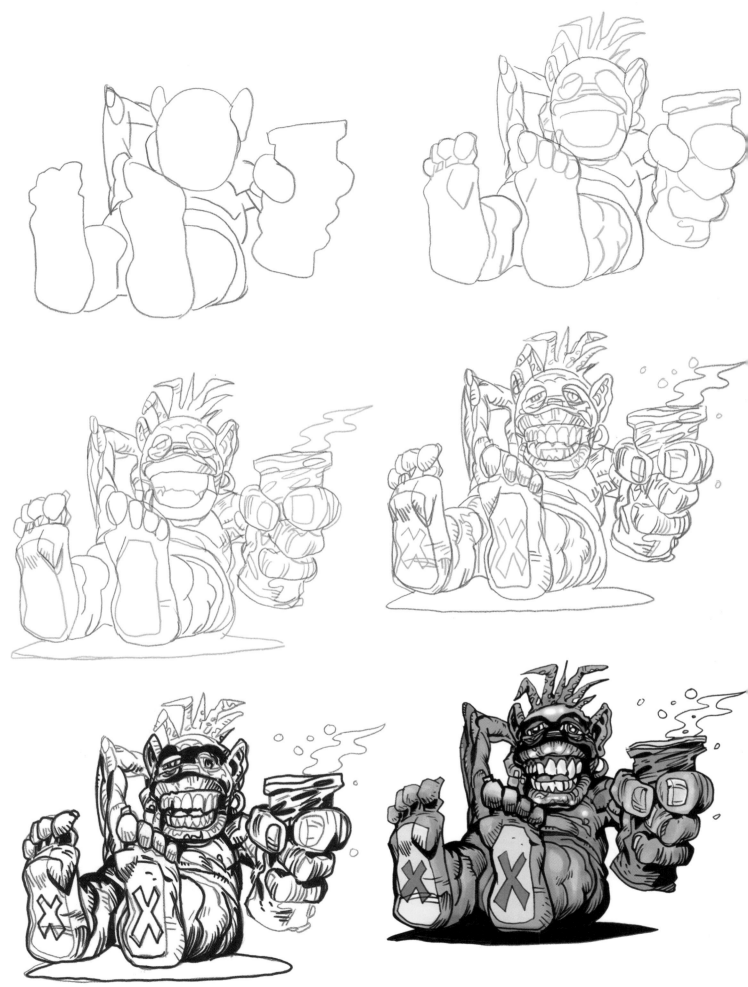

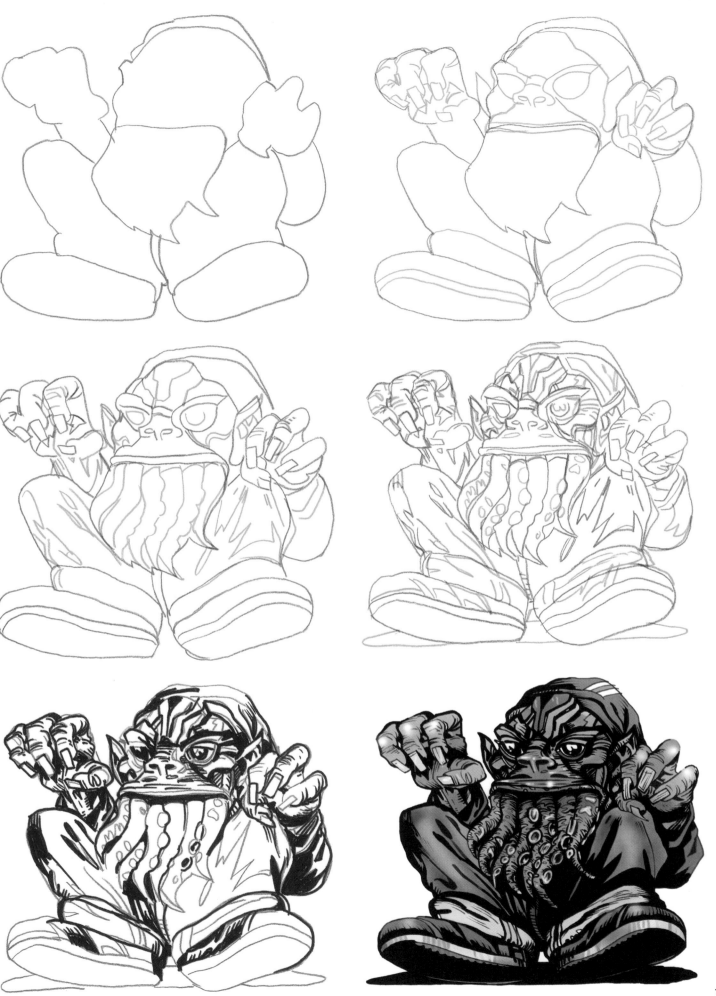

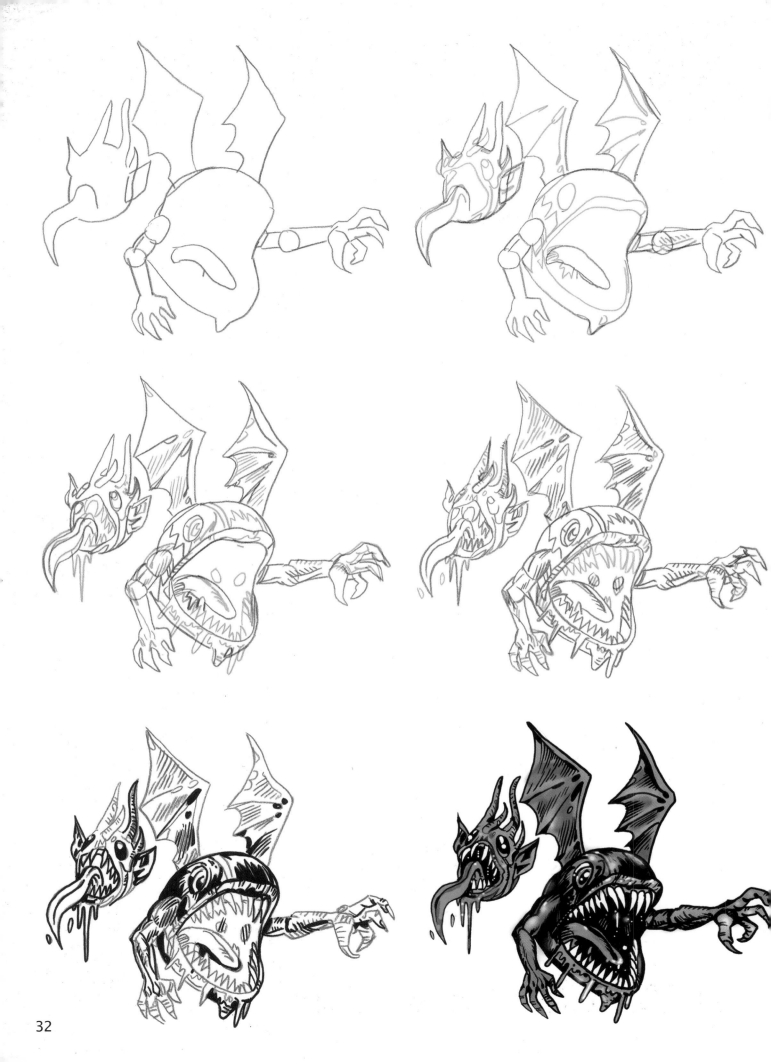